BIOGRAPHIC
KAHLO

BIOGRAPHIC
KAHLO

SOPHIE COLLINS

AMMONITE
PRESS

First published 2018 by
Ammonite Press
an imprint of Guild of Master Craftsman Publications Ltd
Castle Place, 166 High Street, Lewes, East Sussex, BN7 1XU,
United Kingdom
www.ammonitepress.com

Reprinted 2018

ISBN 978 1 78145 341 4

A catalogue record for this book is available from the
British Library.

Publisher: Jason Hook
Concept Design: Matt Carr
Design & Illustration: Matt Carr & Robin Shields
Editor: Jamie Pumfrey
Consultant Editor: Dr Grant Pooke

Colour reproduction by GMC Reprographics
Printed and bound in Turkey

CONTENTS

ICONOGRAPHIC

WHEN WE CAN RECOGNIZE AN ARTIST BY A SET OF ICONS, WE CAN ALSO RECOGNIZE HOW COMPLETELY THAT ARTIST AND THEIR WORK HAVE ENTERED OUR CULTURE AND OUR CONSCIOUSNESS.

INTRODUCTION

At the time of her death in 1954, the work of Frida Kahlo did not loom large on the international art scene. She was respected, certainly, but regarded as minor; a small, sparkling constellation overshadowed by her husband, the artist and kingpin of the Mexican mural movement, Diego Rivera. It did not help that she was not prolific – she had been acutely ill for much of her short life, and her output over a lifetime's painting was maybe 200 pictures.

"FEET, WHAT DO I NEED THEM FOR IF I HAVE WINGS TO FLY?"

—Frida Kahlo, *Diary of Frida Kahlo*, 1953

Perhaps most problematic of all, neither critics nor the public knew quite where to place her. She was often associated with Surrealism (and her painting had a strong fantastical element), but she denied it, insisting that she painted life exactly as she had experienced it.

"I NEVER PAINTED DREAMS. I PAINTED MY OWN REALITY."

—Frida Kahlo, *Time*, 27 April 1953

More than 60 years on, the picture has changed completely. Kahlo is now celebrated as a feminist icon of suffering and artistic achievement, and her paintings are reproduced everywhere in all their fantastic and fearful imagination. On the rare occasion when a significant work appears at auction, collectors, rock stars and oligarchs bid for it, paying millions of dollars.

"I DRANK BECAUSE I WANTED TO DROWN MY SORROWS, BUT NOW THE DAMNED THINGS HAVE LEARNED TO SWIM."

—Frida Kahlo, letter to Ella Wolfe, 1938

It isn't really surprising that Kahlo's life has so completely captured her audience's imagination. After contracting polio at the age of six, she was involved in a trolley car accident in her late teens, which was so horrific that her doctors didn't think she would make it. She did survive, and learned to walk again. However, she was always to be dogged by pain, and the results of her injuries meant she was unable to bear children.

Kahlo's marriage to Rivera initially gave her a role as the supportive wife of a major star. Gradually her confidence grew and she became a painter in her own right, carving out a place for her art in a crowded life of active politics, a huge circle of friends, many lovers and, of course, the overpowering relationship with Diego. Kahlo was complicated, too. She embroidered the truth, exaggerated and sometimes lied outright. Physically tiny, she could outdo Rivera – all 300lb (136 kg) of him – in noisy exhibitionism: it would be a brave host who contemplated an evening with Mr and Mrs Diego Rivera without trepidation.

So, when she set brush to canvas (or, more usually, to Masonite or aluminium), Kahlo had plenty to say – and she was radical in the way she said it. No other artist had so frankly set out the physical problems of their body, the aftermath of failed child-bearing and the tangled relationship between the physical and the psychological. Her art shows the messiness of being human in a way that few others have achieved.

"IF [KAHLO'S] PAINTINGS WERE LOOKED AT CLOSELY, SHE WOULD BECOME A DANGEROUS WOMAN ... PEOPLE WOULD BE LESS COMFORTABLE BUYING HER FRIDGE MAGNETS."

—Margaret A. Lindauer, art historian

FRIDA KAHLO

01
LIFE

"A LITTLE WHILE AGO, NOT MUCH MORE THAN A FEW DAYS AGO, I WAS A CHILD WHO WENT ABOUT IN A WORLD OF COLOURS, OF HARD AND TANGIBLE FORMS ... NOW I LIVE IN A PAINFUL PLANET, TRANSPARENT AS ICE ... IT IS AS IF I HAD LEARNED EVERYTHING AT ONCE IN SECONDS."

—Frida Kahlo, letter to Alejandro Gómez Arias, 29 September 1926

MAGDALENA CARMEN FRIEDA KAHLO Y CALDERÓN

was born on 6 July 1907 in Coyoacán, Mexico City

Frida (she removed the "e" in adulthood to create a less-German form) was the third of the four daughters of Guillermo Kahlo, a photographer of German ancestry who had emigrated to Mexico in 1891, and Matilde Calderón, his second wife, who was of mixed Spanish and indigenous Mexican heritage. Despite a certificate clearly stating the date of her birth, in later life Kahlo liked to claim that she had been born in 1910 – not because she wished to be thought younger, but because it was the year of the Mexican revolution, and she was nothing if not a revolutionary.

Her mother was too ill after her birth to care for the new baby, so an indigenous Mexican woman nursed Kahlo. Later, she attributed her visceral attachment to her native country to the fact that she had drunk Mexico's milk from birth, a belief reflected in her 1937 composition, *My Nurse and I* – one of her most powerful works.

◀ Also born in Mexico City: **Octavio Paz** (1914–98), diplomat, poet and one of Frida's fiercest critics

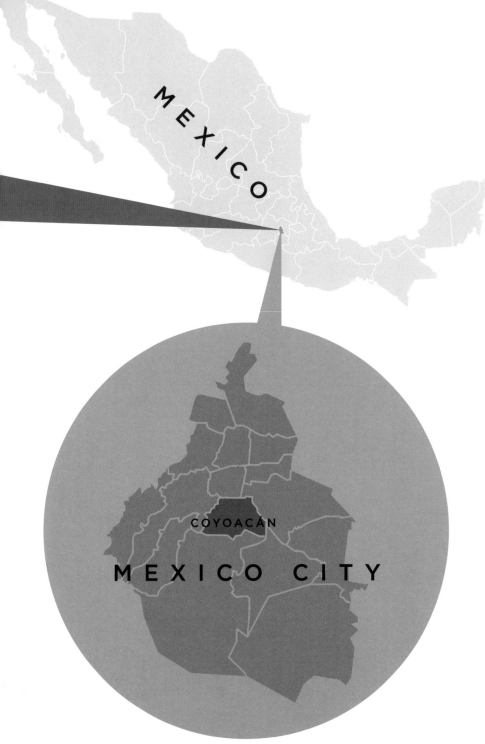

MEXICO

COYOACÁN

MEXICO CITY

THE WORLD IN ...

All her life, Kahlo embroidered events in the same bright but not always true-to-life colours that she used in her paintings. An especially persistent fiction was that she had been born in 1910, rather than 1907.

Events from those two years give us a sense of the world at that time ...

In England, author Rudyard Kipling is awarded the first Nobel Prize for Literature.

In the United States, Oklahoma becomes the 46th state of the Union.

The Ziegfeld Follies premiere in New York City.

46

In New York, the first ever movie stunt is filmed.

THE MEXICAN REVOLUTION BEGINS ...

... AND IN REALITY KAHLO TURNS THREE YEARS OLD IN COYOACÁN, OUTSIDE MEXICO CITY.

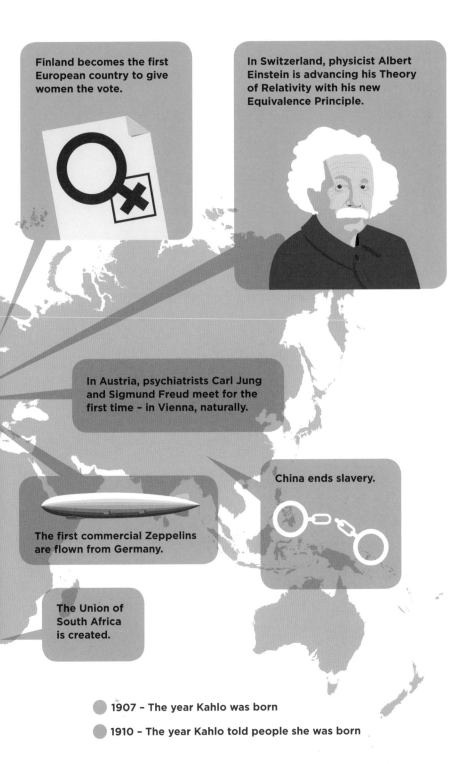

Finland becomes the first European country to give women the vote.

In Switzerland, physicist Albert Einstein is advancing his Theory of Relativity with his new Equivalence Principle.

In Austria, psychiatrists Carl Jung and Sigmund Freud meet for the first time – in Vienna, naturally.

China ends slavery.

The first commercial Zeppelins are flown from Germany.

The Union of South Africa is created.

1907 – The year Kahlo was born

1910 – The year Kahlo told people she was born

WE ARE FAMILY

Kahlo made much of her heritage, claiming that her father was a Jew of Hungarian descent, and her mother was the offspring of an indigenous Mexican photographer and the daughter of a Spanish general. While her mother's story is true, recent research indicates that Guillermo Kahlo (originally Wilhelm Kahlo) came from a German Lutheran background. So his Jewish blood may have existed only in his daughter's imagination.

Isabel González y González
(born *c.* 1848)

Antonio Calderón Sandoval
(born *c.* 1847)

Matilde Calderón y González
(1876–1932)

Matilde
(1898–1951)

Adriana
(1902–68)

Frida
(1907–54)

Cristina
(1908–64)

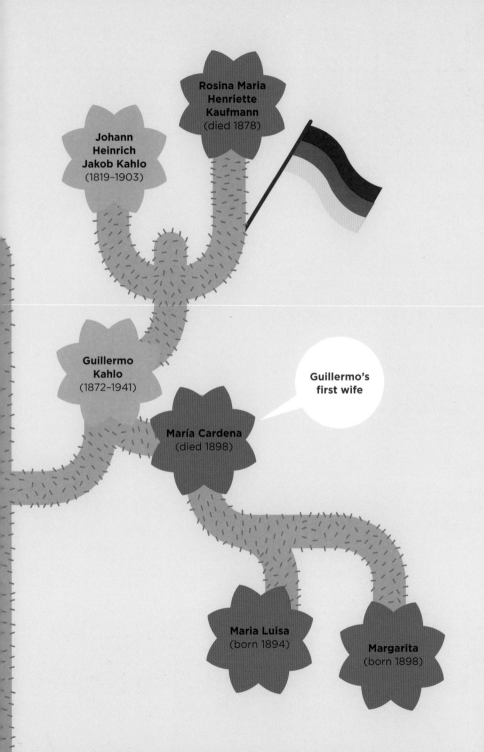

EARLY YEARS

Throughout Frida's early years, Mexico was in political turmoil, going first through a lengthy revolution then, from 1920, descending into civil war. This not only affected Kahlo's family economically, but also formed the backdrop to her growing political consciousness. While an educated middle class sought political freedoms, the peasants of Mexico were struggling to gain basic rights from landowners and overseers.

1922

The government sponsors murals to be painted in public buildings as a way of educating an illiterate public, and thus instigates the Mexican mural movement.

1907

Frida Kahlo is born on 6 July in Casa Azul (the "Blue House") in Coyoacán, then a comparatively rural suburb of Mexico City.

1922

Kahlo starts studying at the prestigious Escuela Nacional Preparatoria, where she is one of only 35 girls out of 2,000 pupils. She intends to become a doctor.

1913

At the age of six, Kahlo contracts polio, and is left with a wasted right leg and a twisted foot.

1913

Kahlo attends the Colegio Aléman, a German elementary school in Mexico City. Her wasted leg attracts mockery from fellow pupils and she is nicknamed "Peg-leg Frieda".

1922

Kahlo sees Diego Rivera for the first time as he works on his mural, *The Creation*, in the school's lecture hall. She joins "The Cachuchas", a group of young, politically active students with socialist-nationalist ideas, named for the peaked caps they wore.

1922

Kahlo changes the spelling of her name to the less Teutonic "Frida".

1923

Kahlo becomes involved with Alejandro Gómez Arias, leader of the Cachuchas, an affair that is to last until 1928, when he falls in love with her friend Esperanza Ordoñez.

1924

Kahlo helps her father with his work, learning the processes of photography in his studio.

1925

Kahlo serves a brief paid apprenticeship with Fernando Fernández, a well-known commercial printer. He encourages her to draw.

1925

On 17 September, Kahlo is badly injured in a collision between a bus and a trolley car. She spends one month in the Red Cross hospital and, encouraged by her parents during her lengthy convalescence at Casa Azul, she starts to paint.

THE ACCIDENT

On 17 September 1925, Kahlo was on a bus that was hit by a trolley car. Several people died, and she was horribly injured. Her right foot and leg – already withered by polio – were crushed, and an iron rail passed right through her pelvis. It was a month before she left hospital and three more before she could stand upright. The after-effects of this accident lasted all her life and were probably the ultimate cause of her death 29 years later.

Alejandro Gómez Arias, Frida's *novio* (boyfriend), gave a vivid account of the accident. The collision had torn her clothes away and she was covered in blood. Bizarrely, someone on the bus had been carrying a packet of gold powder that had scattered over her. As Arias carried her out of the wreckage, onlookers – seeing Frida's red-and-gold body – took her for a dancer, and he heard them exclaiming, "La bailarena! La bailarena!".

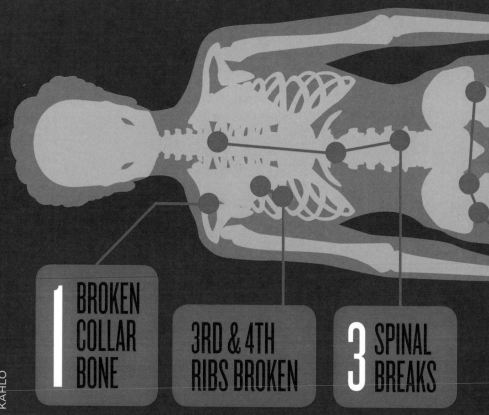

1 BROKEN COLLAR BONE

3RD & 4TH RIBS BROKEN

3 SPINAL BREAKS

SEPTEMBER **17 1925**

MONTH IN HOSPITAL

3 MONTHS BEFORE FRIDA COULD STAND

3 PELVIC BREAKS

11 RIGHT LEG FRACTURES

RIGHT FOOT CRUSHED & DISLOCATED

LIFE GOES ON

Kahlo becomes a member of the Mexican Communist Party.

She meets Diego Rivera through photographer Tina Modotti.

Kahlo is depicted as a young revolutionary handing out weapons in Rivera's *Ballad of the Proletarian Revolution*, a mural painted in the Ministry of Public Education.

1929

Kahlo and Rivera are married on 21 August and Kahlo moves out of Casa Azul, her childhood home. They live first in an apartment in Mexico City and then in Cuernavaca, a city south of Mexico City, where Rivera is painting a mural. She leaves the Communist Party when Rivera is expelled from it.

1930

Kahlo terminates an unviable pregnancy at the beginning of the year.

In November, Rivera and Kahlo move to San Francisco where Rivera has been offered a commission.

1930

Kahlo suffers increasingly from the pain in her injured leg.

She meets Dr Leo Eloesser, who will be her medical advisor for the rest of her life.

Kahlo meets Nickolas Muray, a Hungarian photographer living in America. They start a relationship that lasts (on and off) for the next decade.

1932

Kahlo and Rivera move to Detroit, where Rivera works on another commission.

Kahlo's second pregnancy ends in miscarriage on 4 July.

1933

In March, Kahlo and Rivera move to New York City, where Rivera works on a mural in the Rockefeller Center.

1934

A third pregnancy is terminated at three months, and Kahlo also has an appendectomy. At the same time, she has an operation on her foot and several toes are removed.

Rivera has an affair with Kahlo's younger sister, Cristina, but Kahlo doesn't find out until 1935, when the couple separate.

1936

Kahlo takes her own apartment and lives apart from Rivera for some months. She has an affair with the American sculptor Isamu Noguchi.

Living with Rivera once again, Kahlo has a further operation on her foot.

LIFE

"A MARRIAGE BETWEEN AN ELEPHANT AND A DOVE."

FRIDA KAHLO

HEIGHT	WEIGHT
5 ft 3 in (1.6 m)	98 lb (44 kg)

DIEGO RIVERA

HEIGHT	WEIGHT
6 ft 1 in (1.9 m)	300 lb (136 kg)

Frida Kahlo and Diego Rivera married for the first time on 21 August 1929 (they were subsequently to divorce and then marry again). At 42 to her 22, Rivera was almost twice Kahlo's age, over three times her weight and had already been married twice before. The quotation above is attributed to Kahlo's mother, who criticized him for being too fat and a known womanizer. Most disgusting of all to Matilde, who was a devout Roman Catholic, he was a Communist. Despite this, Rivera recalled that Kahlo's father took him aside to give him a warning: "She's a devil, you know."

Artistically, the two were well matched. Emotionally, their partnership was intense. It was packed with incident, providing unlimited raw material for, in particular, Kahlo's most excoriating self-portraits.

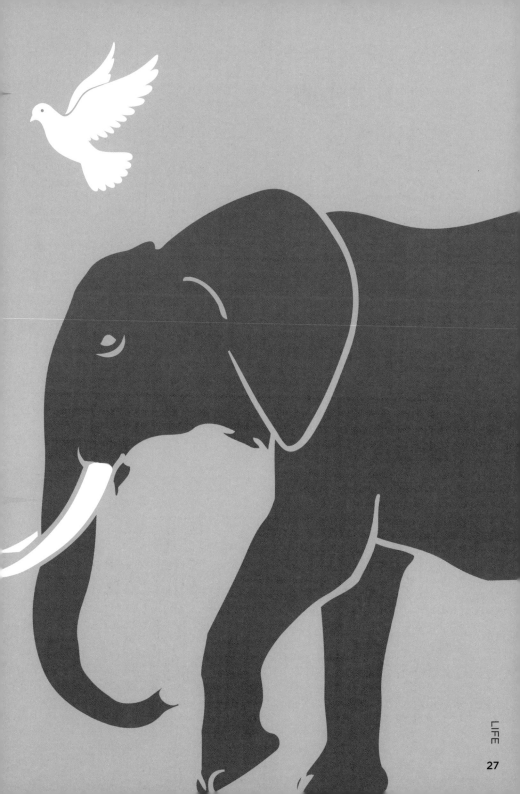

FRIDA FASHION

Kahlo's appealing sartorial style was a very deliberate piece of self-presentation, based on the folk costume of a Tehuana, from Tehuantepec in the south of Mexico. Not only were the long skirts practical, covering her damaged leg, but the clothes' symbolism was important, too. Tehuanas live in a matriarchal society in which property is passed from mother to daughter. This is at odds with the highly patriarchal systems of Mexico, and something of which Frida will have been well aware.

When Kahlo died in 1954, Rivera shut up her rooms in Casa Azul, saying they should not be opened for 50 years. In 2004, the doors were finally unlocked and many of Frida's costumes were seen for the first time since her death. They included:

12 REBOZOS

A shawl made from a piece of cloth that was 70 inches (180 cm) by 33 inches (84 cm). Traditional examples are woven in an ikat pattern, using 14 separate processes.

23 HUIPILS

A loose, square-cut, sleeveless shirt, often heavily embroidered.

38 SKIRTS

Full length, usually with a deep, pleated flounce.

2 TEHUANA HEADDRESSES

or "face huipils", such as Kahlo wears in her *Self-Portrait as a Tehuana* (1943). A combined head-covering and shoulder cape that frames the face, usually made of lace and pleated.

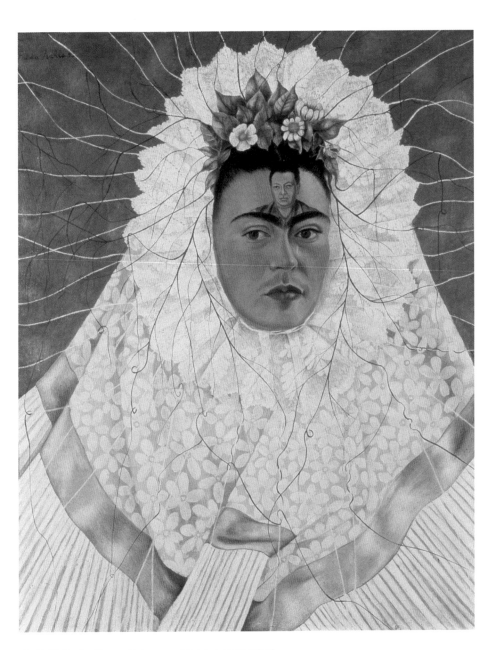

▲ ***Self-Portrait as a Tehuana: Diego on my Mind***
Frida Kahlo, oil on Masonite, 1943
30 x 24 inches (76 x 61 cm)

KAHLO IN LATER LIFE

1937
On 9 January, Marxist revolutionary Leon Trotsky and his wife arrive in Mexico. Kahlo invites them to stay at Casa Azul.

1938
French writer André Breton arrives in Mexico, with the aim of meeting Trotsky. He becomes friendly with Kahlo and Rivera.

1938
In November, Kahlo's first solo exhibition is held at the Julien Levy Gallery in New York City. She exhibits 25 works, and around half are sold.

1939
In March, an exhibition of Kahlo's works opens at Renou & Colle Gallery in Paris. She shows 17 works; André Breton contributes the preface to the catalogue. Kahlo meets many of the Surrealist painters, who take her for one of their own – although she emphatically denies being a Surrealist.

1939
Kahlo returns to Mexico and moves back to Casa Azul where she will live for the rest of her life. Rivera files for divorce and on 6 November, it is finalized.

1940

In September, Kahlo travels to San Francisco for treatment from Dr Eloesser. On 8 December, while in America, she remarries Rivera.

1941
Guillermo Kahlo dies from a heart attack.

1942
Kahlo starts writing the intimate diary that she will keep for the rest of her life.

1943
Kahlo becomes a professor at La Esmeralda School of Art. Her poor health means that the majority of her classes are taught at Casa Azul.

1944
Kahlo wins second prize at the annual art exhibition held at the Palacio de Bellas Artes for her painting *Moses*.

1948
Kahlo rejoins the Mexican Communist Party.

1950
Kahlo spends nine months of the year in hospital, and has a total of seven operations on her spine.

1951
Kahlo is largely confined to a wheelchair, and taking large quantities of painkillers.

1952
She becomes involved with the Peace Movement. Rivera depicts her collecting signatures for the cause in his mural *The Nightmare of War and the Dream of Peace*.

1953
In April, the first solo exhibition of Kahlo's works in Mexico is held at the gallery of Lola Alvarez Bravo. The artist, unable to walk, is carried with her bed to the opening night.

In August, Kahlo's right leg is amputated below the knee.

1954
Kahlo dies at home on 13 July.

1958
A year after Rivera's death in 1957, Casa Azul is opened as Museo Frida Kahlo, and gifted to the Mexican nation in accordance with his wishes.

8 FACTS ABOUT FRIDA

1 Kahlo's favourite song was a popular Mexican tune called 'Cielito Lindo', which translated as "little beautiful sky". The song is still played by mariachi bands today.

2 When she was just seven years old, Frida helped her older sister, Matilde, escape from the family home. Matilde felt that she could no longer live under her mother's rule and ran off to live with her boyfriend.

5 In photographs, it is rare to see Frida looking anything but solemn. A lifetime of health problems, as well as her smoking habit and diet of sweets, led to her having rotten teeth. Although she later wore dentures, it is thought that she kept her mouth closed and refused to smile so as to keep her teeth hidden.

6 Kahlo's favourite perfume was a 1937 scent called 'Shocking', produced by fashion designer, Elsa Schiaparelli.

3

In 1939, Kahlo was invited by André Breton to participate in an exhibition in Paris and submitted a painting called *The Frame*. This was bought by the Louvre, making Kahlo the first Mexican artist to be featured in the museum.

4

Kahlo's first solo exhibition in Mexico was held in 1953, just months before her death. Due to her failing health she was brought to the gallery in an ambulance and carried in on a stretcher to a waiting bed, where she remained for the rest of the evening.

7

There have been a number of successful books and films about the life of Kahlo, as well as two feature length movies, *Frida, Naturaleza Viva* (1983) and *Frida* (2002). In 2017, Kahlo featured as a character in the Disney Pixar animated movie, *Coco*.

8

Kahlo was a revolutionary to the end. In her last public appearance, suffering with severe bronchopneumonia, she attended a rally to protest against the US intervention in Guatemala.

DEATH OF FRIDA

In the early hours of 13 July 1954, having been suffering from a high fever in the previous days, Kahlo was found dead in her bed by a nurse. The official cause of death was registered as a pulmonary embolism, though rumours of suicide persisted for some time.

After Kahlo's death, Rivera arranged for her to lie in state for a day at the Palace of Fine Arts. On the afternoon of 14 July, her body was taken for cremation. There was a near-riot when it arrived at the crematorium, as admirers tried to pull the rings from her fingers as souvenirs. In one final drama, as the coffin containing her body entered the open furnace, a blast of heat caused the muscles to contract, and she appeared to sit up in her coffin, her hair in flames.

FRIDA'S FINAL RESTING PLACE

Kahlo's ashes are kept in a pre-Columbian container at her home, Casa Azul, now the Museo Frida Kahlo, in Mexico City.

MEXICO CITY

AV. RIO CHURUBUSCO

FRIDA
KAHLO

02
WORLD

"THEY ARE SO DAMN 'INTELLECTUAL' AND ROTTEN THAT I CAN'T STAND THEM ANY MORE ... I (WOULD) RATHER SIT ON THE FLOOR IN THE MARKET OF TOLUCA AND SELL TORTILLAS, THAN HAVE ANYTHING TO DO WITH THOSE 'ARTISTIC' BITCHES OF PARIS."

—Frida Kahlo, on the European Surrealists, in a letter to Nickolas Muray, 16 February 1939

THE AMERICAN ODYSSEY

From late 1930 to December 1933, Kahlo and Rivera spent much of their time in the USA. While Rivera worked on large, public commissions and exhibitions, Kahlo painted – sporadically at first, then more consistently. She exhibited publicly for the first time in San Francisco, and between 1931 and 1933 produced some of her definitive works.

San Francisco, 1930–31

- Rivera paints a mural in the Stock Exchange, has shows in a number of galleries and lectures at various local institutions.

- Kahlo meets Dr Leo Eloesser, who is to be her trusted medical advisor for the rest of her life, and paints an early portrait of him. She makes a number of other portraits, including a fantastic reimagining of the horticulturalist, Luther Burbank, whom she depicts putting down roots into the soil.

Detroit, 1932

- Rivera paints a mural at the Detroit Institute of Arts, a commission from the Ford Motor Company.

- In July, Kahlo miscarries. On her recovery, she paints *Henry Ford Hospital*, the first work displaying her characteristic mix of dark reality and fantasy. Before the year's end, she also produces *My Birth* and *Frida Kahlo: Self-Portrait on the Border between Mexico and the USA*.

- In September, Kahlo travels back to Mexico, where her mother is dying. She returns to Detroit after Matilde's death.

New York, 1933

- Rivera completes a commission at the Rockefeller Center, and causes a scandal by including a portrait of Lenin. As a result, the commission is cancelled.

- Among other increasingly confident paintings, Kahlo completes *My Dress Hangs There*, which shows her Tehuana clothes hanging empty against a complicated American landscape.

- In December, Kahlo and Rivera return to Mexico.

New York, 1931

- In June, Kahlo and Rivera head back to Mexico, returning to New York in November.

- Rivera has a retrospective of his work at the Museum of Modern Art, which opens in December.

- Kahlo exhibits *Frieda and Diego Rivera* at the 6th Annual Exhibition of Women Artists in San Francisco, the first time she has shown her work.

THE LANGUAGE OF DRESS

Today, the image of Frida looking supremely comfortable in Mexican clothes can make us forget that this was hardly ever the dress of those around her. "Little Mrs. Kahlo", as she was patronizingly called in one article during her first visit to America in her mid-20s, knew already how to make an impact with her personal style. As the daughter of a photographer, she was used to posing, and she was very aware of the impression she made. Throughout her life she would use clothes and accessories in her art to express her state of mind.

01 Kahlo loved dressing up in men's clothes – some family group snaps show the teenager dressed in a neatly tailored three-piece suit, with slicked-back hair and shiny black shoes. Later, the suit would express Diego's rejection of her. In *Self-Portrait with Cropped Hair* (1940), Kahlo wears an outsized suit, possibly her errant husband's, and long locks of her hair are scattered on the floor around her.

02 Colourful, comfortable and immediately recalling her home country, Kahlo's customary choice of traditional Mexican clothing made a vivid impression on everyone who met her. She had literally dozens of combinations of huilpils and skirts, from all parts of Mexico.

03 The clothing that we associate least with Kahlo is the conventional European woman's suit or dress, but she occasionally depicted it, usually set against her traditional Mexican clothes as a means of stressing the differences between Mexico and the United States.

A LIFE OF PAIN

Kahlo was operated on over 30 times between the ages of six (when she contracted polio) and 46 (the year before she died, when her right leg was amputated below the knee). In a diary of her last decade, she documented her procedures in a folk art style which recalls the milagros (religious folk charms) and votives that were offered up with prayers for healing in every church in rural Mexico. Her drawings are highly decorative, but also frank about the pain and the indignity that she endured in these efforts to maintain her damaged body.

1913	1953	1954
CONTRACTS POLIO	RIGHT LEG AMPUTATED	DIES 13 JULY

| 6 YEARS OLD | 46 YEARS OLD | 47 YEARS OLD |

30 OPERATIONS + POSSIBLY THREE MORE

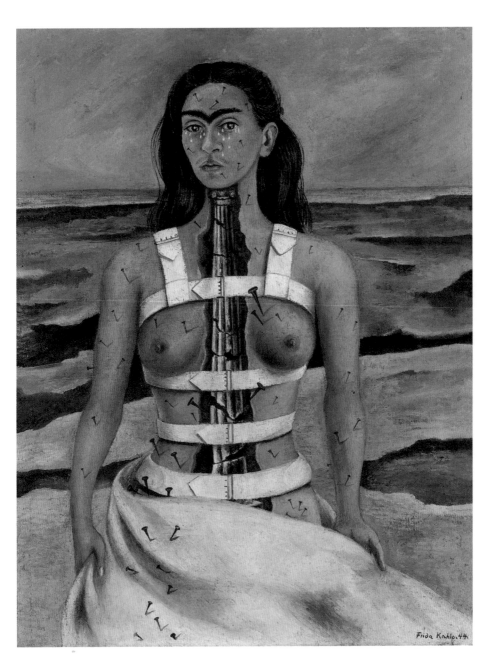

▲ *The Broken Column*
 Frida Kahlo, oil on Masonite, 1944
 17 x 13 inches (43 x 33 cm)

ARTIST'S LUNCH

Whenever Rivera was near enough and Kahlo was well enough, she brought him lunch in a covered basket every day. Frida was a good cook and had been educated in Diego's tastes by his second wife, Lupe Marín, who had even recommended touches such as the inclusion of a napkin with "I love you" embroidered on it. Although Rivera was frequently on a diet (theoretically at least), there would always be generous quantities of fresh tortillas and guacamole, with, perhaps, a stew such as duck *molé*. There might also be *huitlacoche*, a grey fungus that grows on corn, made into a dark, savoury mixture with chillies and onions.

LUNCH

Flour tortillas
Guacamole
Duck *molé*
Stewed *huitlacoche*

TORTILLAS EATEN

● **Diego**

● **Frida**

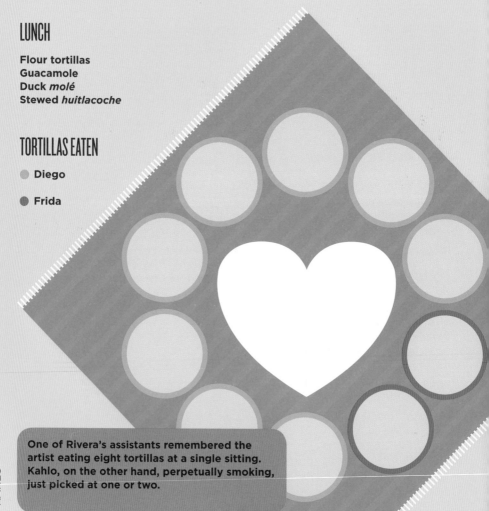

One of Rivera's assistants remembered the artist eating eight tortillas at a single sitting. Kahlo, on the other hand, perpetually smoking, just picked at one or two.

GOOD FOOD = GOOD WORK?

If you are what you eat, then the range of foods eaten by great artists could go a long way to explaining the variety of their output. Poverty and a natural asceticism often led Van Gogh to dine on coffee and a piece of bread, but it didn't stop him painting all day. Georgia O'Keeffe on the other hand – a keen cook and a devotee of fresh, seasonal ingredients – held the firm view that healthy food, not too little, not too much, would result in better creative work. Both Diego and Frida clearly believed that the best work was done on a full stomach.

PICASSO

Pablo Picasso was very well looked after by his wife and final companion, Jacqueline Roque. The artist did not start work until after a substantial lunch, often of three courses, and usually including a salad and cheese. Even in his 90s, he could put in a full afternoon's work afterwards.

MONET

Claude Monet, a famous gourmet, would ask his cook to try dishes he had enjoyed elsewhere, resulting in the incongruous appearance of a very British Yorkshire pudding at his very French lunch table.

WARHOL

Andy Warhol usually had his lunch made for him by his mother. This often consisted of Campbell's tomato soup with a lettuce-and-tomato sandwich. Warhol preferred watching the television to conversation while he ate.

SURREALISM

Freud's theories on dreams

Freedom from deliberate actions

The embrace of incoherence

The importance of dreams

The "authentic self"

Willingness to depict violent and
disturbing images

Desire to push against the boundaries
of "acceptable" behaviour

An irreverent whimsicality

Enthusiasm for painting reality, but with a fantastical edge

Contempt for the over-intellectualization of art

KAHLO

"I'M NOT A SURREALIST."

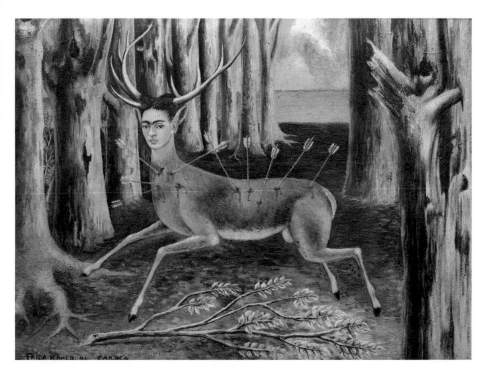

▲ **The Wounded Deer**
Frida Kahlo, oil on Masonite, 1946
8 ³/₄ x 11 ³/₄ inches (22 x 30 cm)

Kahlo blew hot and cold on the Surrealist movement. She liked – and shared – its rule-breaking qualities and its disdain for convention, but came to loathe what she perceived as the mannered approach and the intellectualism of its leading stars, such as André Breton and Max Ernst. Diego Rivera claimed Kahlo was a realist – she simply painted her world as she saw it, real rather than surreal. When she depicted her miscarriages, or drew her wrecked spine, or even when she characterized herself as a wounded deer, pierced with arrows and fleeing through the forest, she was painting the way in which she experienced her life. On occasion, though, she admitted to enjoying it. She wrote in her diary that: "Surrealism is the magical surprise of finding a lion in the wardrobe where you were 'sure' of finding shirts."

> "**I ONLY WANT THREE THINGS IN LIFE:**
> 1 TO LIVE WITH DIEGO
> 2 TO CONTINUE PAINTING
> 3 TO BELONG TO THE COMMUNIST PARTY."
>
> —Frida Kahlo, 1954

TROTSKY

- Kahlo met Trotsky in the USA in 1930.

- They had a short affair in 1937.

- Kahlo painted *Self-Portrait Dedicated to Leon Trotsky* (1937) after the liaison; Trotsky hung it on his study wall.

- In 1940, Trotsky was assassinated in Mexico; Kahlo was briefly arrested on suspicion of being involved in the murder, but was released without charge.

Kahlo was noisily political in her girlhood. By the time Rivera painted her in 1928 – red-shirted, in his mural, *Ballad of the Proletarian Revolution* – she was, like him, a member of the PCM, the Communist Party of Mexico. However, Rivera was expelled from the Party in 1929 and Kahlo followed him. Shortly afterwards, during their stay in America, they met Trotsky, leader of the anti-Stalinist left. Trotsky was to stay with them for a while when he and his wife arrived in Mexico. However, Rivera and Trotsky fell out, and were not reconciled before the latter's murder. After Trotsky's death, there was a drift back to "conventional" Stalinism. At the time of her own death, Kahlo may have considered herself a Stalinist.

STALIN

- **Kahlo never went to Russia or met Stalin, but Stalinism was the default politics of left-wing intellectuals in Mexico in the 1940s and '50s.**

- **Kahlo rejoined the Communist Party in 1948.**

- **One of Kahlo's last paintings was *Self-portrait with Stalin* (c. 1954).**

- **On 2 July 1954, just 11 days before her death, Kahlo attended a Communist demonstration against the CIA's interference in Guatemalan politics.**

NO DEGREES OF SEPARATION

In the crowded world of Kahlo's relationships, it would sometimes be hard to establish one degree of separation, much less six. Her relationship with Rivera was of necessity an open one: he never pretended to be faithful, but both maintained that their connection went far beyond mere faithfulness.

Kahlo moved freely between friends and lovers, male and female, not unusually in the context of her peers. While Rivera tolerated her intimate friendships with women, he became irrationally jealous about her affairs with men. Both had voracious appetites for friendship as well as love. The links here are far from comprehensive, but give an idea of their entangled connections across a range of different worlds.

Nickolas Muray photogra

Leon Trotsky politician

Heinz Berggruen art critic

Isamu Noguchi sculptor

Paulette Goddard film star

José Bartoli artist

Josephine Baker dancer

Lupe (Guadalupe) Marín novelist

Miguel Covarrubias illustrator & artist

André Breton artist

Jacqueline Breton artist

Marcel Duchamp artist

Tina Modotti photographer

Edward Weston photogra

● Lover

● Friend

● Family

● Patron

● Spouse

FRIDA KAHLO

Nelson Rockefeller industrialist

Henry Ford industrialist

Raquel Tibol art critic

María Félix movie star

Dolores del Río movie star

Edward G. Robinson movie star

Clare Boothe Luce author & politician

Cristina Kahlo model

Dr Juan Farill doctor

Dr Leo Eloesser doctor

Dolores Olmedo art collector

Emmy Lou Packard artist & printmaker

Lucienne Bloch artist & muralist

Imogen Cunningham photographer

DIEGO RIVERA

THE MENAGERIE

Kahlo's animals were an important part of her household. Visitors often commented on her menagerie and Kahlo's pets are constantly mentioned in her letters. From the mid-1930s, animals appear alongside her in self-portraits just as often as other people do. A few stars, such as Fulang-Chang, the spider monkey, and Bonito, the parrot, are named in paintings. Others, such as her pack of hairless Mexican Itzcuintli dogs, appear but aren't named. As Kahlo's portraits are often called by different names in different places (and, of course, no-one is agreed exactly how many there are to start with), finding precise numbers is impossible.

APPEARANCE OF ANIMALS IN PAINTINGS

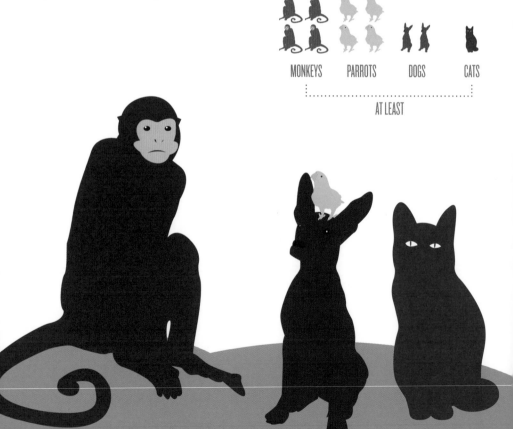

MONKEYS PARROTS DOGS CATS

AT LEAST

FRIDA
KAHLO

03
WORK

"THE ART OF FRIDA KAHLO

—André Breton, *Time*, 14 November 1939

S A RIBBON AROUND A BOMB."

A PRODUCTIVE CAREER

Despite her often catastrophic health problems and many dramas in her personal life, Kahlo painted fairly consistently for more than three decades. She worked regardless of her physical weakness, from her first recorded painting in 1924 to her last in 1954. Numerous photographs from her later years, often taken when she was seriously ill, show her working in bed, just as she had when she took up brushes after her accident in 1925. The total number of paintings produced by Kahlo isn't known, although an educated estimate stands at about 200. There are 142 officially documented, but Kahlo didn't keep detailed records herself and quite a large number, particularly from early in her career, are thought to have been lost or simply never recorded.

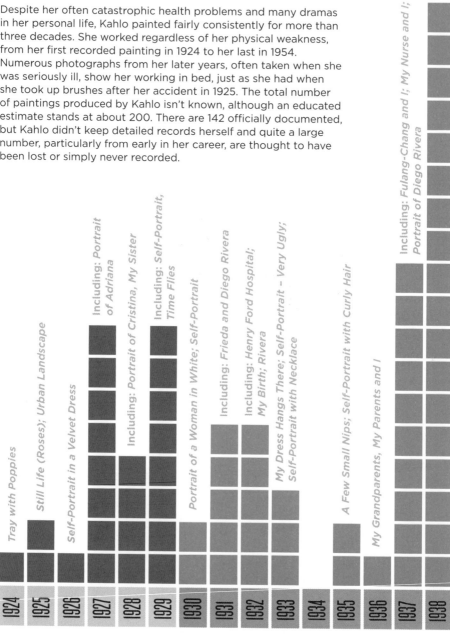

Tray with Poppies

Still Life (Roses); Urban Landscape

Self-Portrait in a Velvet Dress

Including: Portrait of Adriana

Including: Portrait of Cristina, My Sister

Including: Self-Portrait, Time Flies

Portrait of a Woman in White; Self-Portrait

Including: Frieda and Diego Rivera

Including: Henry Ford Hospital; My Birth; Rivera

My Dress Hangs There; Self-Portrait – Very Ugly; Self-Portrait with Necklace

A Few Small Nips; Self-Portrait with Curly Hair

My Grandparents, My Parents and I

Including: Fulang-Chang and I; My Nurse and I; Portrait of Diego Rivera

Including: Survivor

1924 1925 1926 1927 1928 1929 1930 1931 1932 1933 1934 1935 1936 1937 1938

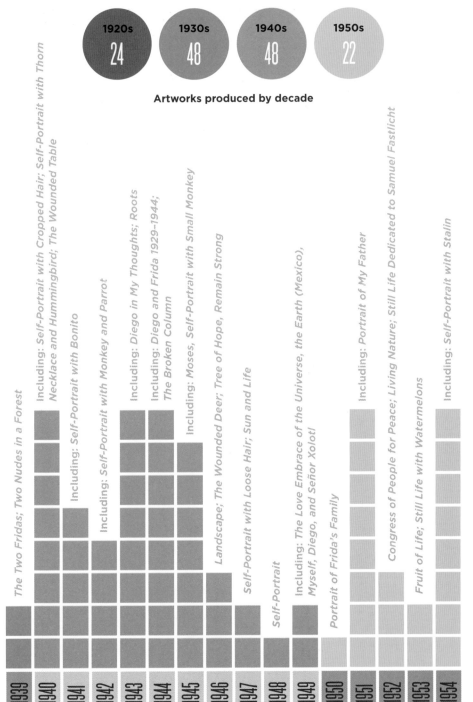

Artworks produced by decade

1920s	1930s	1940s	1950s
24	48	48	22

The Two Fridas; Two Nudes in a Forest — 1939

Including: Self-Portrait with Cropped Hair; Self-Portrait with Thorn Necklace and Hummingbird; The Wounded Table — 1940

Including: Self-Portrait with Bonito — 1941

Including: Self-Portrait with Monkey and Parrot — 1942

Including: Diego in My Thoughts; Roots — 1943

Including: Diego and Frida 1929-1944; The Broken Column — 1944

Including: Moses, Self-Portrait with Small Monkey — 1945

Landscape; The Wounded Deer; Tree of Hope, Remain Strong — 1946

Self-Portrait with Loose Hair; Sun and Life — 1947

Self-Portrait — 1948

Including: The Love Embrace of the Universe, the Earth (Mexico), Myself, Diego, and Señor Xolotl — 1949

Portrait of Frida's Family — 1950

Including: Portrait of My Father — 1951

Congress of People for Peace; Living Nature; Still Life Dedicated to Samuel Fastlicht — 1952

Fruit of Life; Still Life with Watermelons — 1953

Including: Self-Portrait with Stalin — 1954

BIOGRAPHIC FRIEDA AND DIEGO RIVERA

Kahlo painted this work, which she called a wedding portrait, in 1931, while the couple were in San Francisco. She included a full legend on the pink banner above them: "Here you see us, me Frieda Kahlo, with my beloved husband Diego Rivera. I painted these portraits in the beautiful city of San Francisco California for our friend Mr Albert Bender, and it was in the month of April in the year 1931." Consciously flat and quite primitive in effect, the painting is full of coded elements. Rivera stands, square and solid, large feet planted, next to his bride who, by contrast, seems almost to float on minute feet, her hand lightly placed over his.

BANNER

In the style of colonial Mexican art, this states the purpose, location and subject of the painting. Banners were a regular feature of colonial art, often containing extended "captions" to a work.

REBOZO, OR SHAWL

The traditional all-purpose shawl, wrap, baby-carrier or backpack, used all over Central and South America.

PALETTE AND BRUSHES

These are used to identify Rivera as the artist. In this painting, Kahlo's role is as his helpmeet and companion. She is not yet asserting her own identity as an artist. (Incidentally, Rivera was not precious about his palette, habitually using an old kitchen plate for the purpose.)

DRESS

In a Mexican folk style, with a deep flounce on the skirt, stressing Kahlo's Mexican heritage.

BACKGROUND

Another reference to colonial Mexican art, in which backgrounds were rarely anything other than flat, rather neutral colour, without anything to distract from the painting's subject.

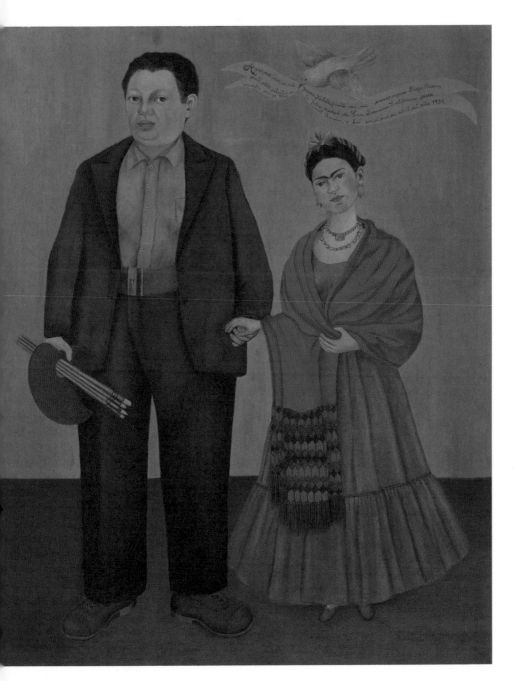

▲ ***Frieda and Diego Rivera***
Frida Kahlo, oil on canvas, 1931
39 x 31 inches (100 x 79 cm)

FRIDA'S FIRST SHOW

Kahlo's first exhibition was held at the Julien Levy Gallery in New York City. It opened in November 1938 and showed 25 of her works, including a number that would attain iconic status. The works were priced between $100 and $600. Note that the titles Kahlo gave her paintings sometimes changed over time, so some paintings became better-known by another name.

MANHATTAN

Julien Levy Gallery, 15 East 57th Street, New York City

01 *Eye*
02 *Girl with Death Mask ("She Plays Alone")*
03 *Survivor*
04 *Xochitl*
05 *Tunas*
06 *Flowers – I Belong to My Owner*
07 *Henry Ford Hospital ("The Lost Desire")*
08 *They Asked for Planes and Only Got Straw Wings*
09 *Remembrance of an Open Wound*
10 *Memory ("The Heart")*
11 *The Deceased Dimas ("Dressed Up for Paradise")*
12 *Portrait of Luther Burbank*
13 *My Birth*

14 *A Few Small Nips ("Passionately in Love")*
15 *My Nurse and I*
16 *Fulang-Chang and I*
17 *Still Life with Pitahayas*
18 *Self-Portrait with Itzcuintli Dog*
19 *Four Inhabitants of Mexico ("The Square is Theirs")*
20 *My Grandparents, My Parents and I ("My Family")*
21 *The Fruits of the Earth*
22 *My Dress Hangs There*
23 *Self-Portrait Dedicated to Leon Trotsky ("Between the Curtains")*
24 *What the Water Gave Me*

PRICE

$100
$150
$200
$250
$300
$400
$450
$600

01 02 03 04

05 06

09

07 08

10 11

12 13 14

15 16 17

18 19 20

21

22 23

Total value of Frida Kahlo's first exhibition

$6,550

Equivalent to $107,000 at today's prices

24

FRIDA KAHLO

Frida Kahlo and Georgia O'Keeffe certainly knew each other, and there were even rumours – probably unfounded – that they had had an affair. However, these two icons of feminism were very different: Kahlo was violently emotional and unconstrained, while O'Keeffe was ascetic in her habits and notably restrained.

200 PAINTINGS

LIFE & WORK

WORKED 30 YEARS

WORKED 78 YEARS

KAHLO 1907–54

O'KEEFFE 1887–1986

GEORGIA O'KEEFFE

2,000 PAINTINGS

AFFILIATED MOVEMENTS

KAHLO — Surrealism (during her life); **Magical Realism** (after her death)

O'KEEFFE — Modernism, Precisionism

HEALTH DIFFICULTIES

Polio aged 6; trolley car accident in 1925 and its later ramifications

Nervous breakdown in the 1930s; failing eyesight from the late 1970s

SUBJECT MATTER

Her life and its difficulties; Mexico – its people and landscapes

Flowers, the desert, buildings (she strongly denied that her flower paintings had any sexual content)

KAHLO ON COLOUR

Kahlo was keenly conscious of colour and its use in her work was never accidental. She used a varied and often vivid palette, but some things were constant: few painters can have depicted blood so often. In her journal, Kahlo explored what different colours meant to her, writing each description in the matching pencil colour.

Some references are local and specific:
Tlapali is the Aztec word for colour; *molé* is the rich, brown, chocolate-spiced sauce of Mexican cuisine; and the prickly pear (the *nopal cactus*) "bleeds" juice that is deep red when dry.

GREEN
"Warm and good light."

LEAF GREEN
"Leaves, sadness, science. The whole of Germany is this colour."

YELLOWISH GREEN
"More madness and mystery. All the phantoms wear suits of this colour ... or at least underclothes."

YELLOW
"Madness, sickness, fear. Part of the sun and of joy."

DARK GREEN

"Colour of bad news
and good business."

BROWN

"Colour of *molé*, of the
leaf that goes. Earth."

REDDISH PURPLE

"Aztec. *Tlapali*.
Old blood of prickly
pear. The most
alive and oldest."

MAGENTA

"Blood?"

NAVY BLUE

"Distance.
Also tenderness
can be of this blue."

BLACK

"Nothing is black,
really nothing."

**The colour descriptions are quoted from Frida's journal,
published as *The Diary Of Frida Kahlo*, 2005**

SIZE MATTERS?

Despite their forceful impact, Kahlo's works can seem surprisingly small on the gallery wall – in reproduction, enthusiasts often imagine them much larger. But she could work at a large scale – her biggest work, *The Wounded Table* (now lost), was over 96 inches (244 cm) in length, and her smallest, an oval miniature self-portrait, just 1½ inches (4 cm) in height. *The Two Fridas*, probably her best-known self-portrait, is also considerably bigger than those two other enigamatic ladies, Leonardo's *Mona Lisa* and Vermeer's *Girl with a Pearl Earring*.

Black Iris III
Georgia O'Keeffe
Oil on canvas, 1936
36 x 30 inches
(91 x 76 cm)

The Wounded Table
Frida Kahlo
Oil on canvas, 1940
48 x 96 inches
(122 x 244 cm)

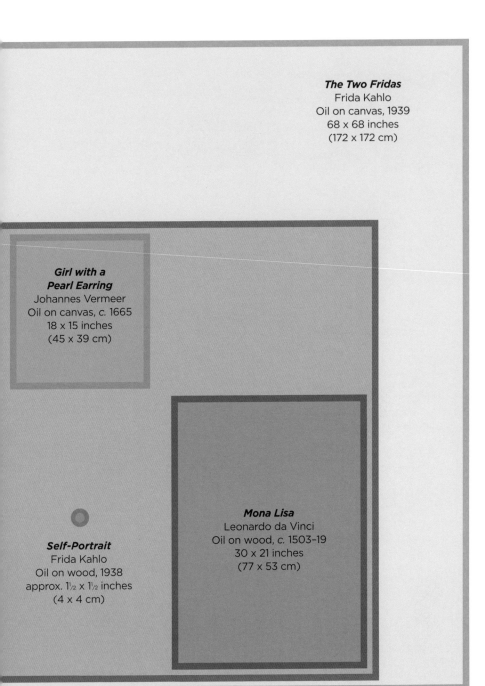

The Two Fridas
Frida Kahlo
Oil on canvas, 1939
68 x 68 inches
(172 x 172 cm)

**Girl with a
Pearl Earring**
Johannes Vermeer
Oil on canvas, c. 1665
18 x 15 inches
(45 x 39 cm)

Mona Lisa
Leonardo da Vinci
Oil on wood, c. 1503–19
30 x 21 inches
(77 x 53 cm)

Self-Portrait
Frida Kahlo
Oil on wood, 1938
approx. 1½ x 1½ inches
(4 x 4 cm)

THE TORSO

Within the torso a fractured, damaged spine can be seen, reflecting Kahlo's other medical problems and vulnerabilities.

THE SNAIL

She explained the snail by saying that it represented the agonizingly slow pace of the miscarriage, which took place over two or three weeks before she was admitted to hospital.

THE FOETUS

Kahlo made no secret of her longing for a boy, "a little Diego", and has shown the foetus as male, positioned directly over her haemorrhaging body.

THE PELVIS

Kahlo studied medical books to get this drawing of a female pelvis accurate in all its details. She had been told by a number of doctors that her own damaged pelvis gave her little chance of carrying a child to term.

THE VICE

A vice-like piece of machinery; Kahlo later claimed this stood for the mechanical aspect of the miscarriage, although she told others it, too, represented her pelvis.

THE ORCHID

Rivera brought Kahlo florid orchids in the hospital, and, observing that they looked fleshy and sexual, she included one among the symbols in her painting.

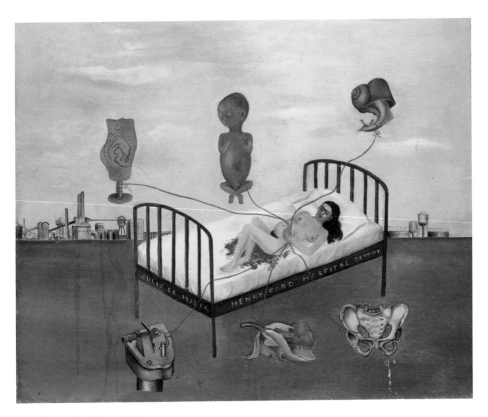

▲ **Henry Ford Hospital**
Frida Kahlo, oil on metal panel, 1932
12 x 15 inches (30 x 38 cm)

Henry Ford Hospital is a small work, just 12 x 15 inches (30 x 38 cm), painted on a sheet of aluminium. At first glance, it resembles votive paintings (also done on metal), which will have had an everyday familiarity for Kahlo. She draws on their simplicity to depict the harrowing aftermath of the miscarriage she suffered at Henry Ford Hospital during the Riveras' stay in Detroit. Frida lies bleeding and naked on a bed; the six "meanings" of the painting are attached to her by bloody red ribbons.

THE ARTIST'S STUDIO

Kahlo's studio at Casa Azul can be visited today, and the whole array of art materials is still laid out as she kept them when they were in daily use. All of her paintings were done in oils, but she used a lot of pastels and coloured inks for sketches and for drawing in her journal. The only decoration hanging on the wall is a large poster, *Intra-Uterine Life*, showing the development of the human child in the womb, which Kahlo used for reference in her work.

OIL PAINTS

PASTELS

EASEL

PALETTE

BRUSHES

PESTLE AND MORTAR,
FOR GRINDING PIGMENT

ALUMINIUM
PANELS FOR
PAINTING ON

MASONITE
BOARDS FOR
PAINTING ON

JARS OF POWDERED AND
METALLIC PIGMENTS

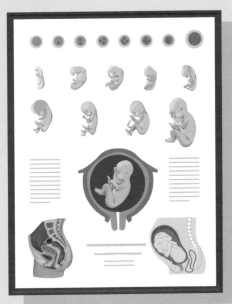

COLOURED INKS

POSTER ON INTRA-UTERINE LIFE

THE SELF-PORTRAITS

Kahlo was by far her own favourite subject: there are 55 self-portraits, depicting her in every imaginable situation, from her birth to her anticipated death. She often shows herself standing solo, eyes on the onlooker, or accompanied by her pets – the wide-eyed, long-armed spider monkeys and the little green parrots that she kept at home. In other portraits she shows harrowing scenes: lying on a hospital bed after a miscarriage, or in the act of being born, or being suckled by a nurse who has the blank, stony face of a pre-Columbian statue.

30 SELF-PORTRAITS ON HER OWN

55 SELF-PORTRAITS

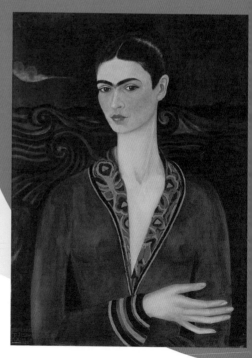

▲ *Self Portrait with Velvet Dress*
Frida Kahlo, oil on canvas, 1926
31 x 23 inches (79 x 58 cm)

11 SELF-PORTRAITS WITH ANIMALS

7 SELF-PORTRAITS WITH OTHERS

6 SELF-PORTRAITS WITH RIVERA

1 SELF-PORTRAIT AS AN ANIMAL

OTHER SELF-PORTRAITISTS

ALBRECHT DÜRER (1471–1528)

The German painter and printmaker was a successful artist in his early 20s and produced at least 12 self-portraits, including three oil paintings and four altarpieces. His *Self-Portrait at 28*, currently housed at the Alte Pinakothek, Munich, is one of his most iconic works.

REMBRANDT VAN RIJN (1606–69)

The prolific Dutch painter made a number of self-portraits over five decades, offering a unique view of the artist throughout his life. The number of paintings was thought to be around 90, though research later revealed that many of these were created by his students, wishing to replicate the great master. The count of securely attributed works has since been reduced to fewer than 50.

BIOGRAPHIC SELF-PORTRAIT WITH THORN NECKLACE AND HUMMINGBIRD

Painted shortly after her divorce from Rivera, which was finalized in December 1939, this is one of Kahlo's most famous works, crammed with symbolism.

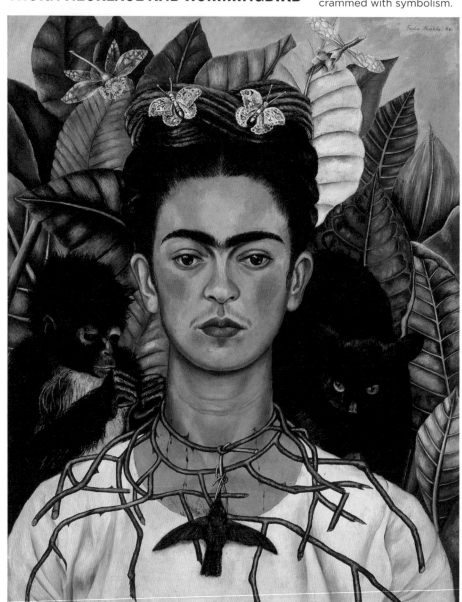

▲ **Self-Portrait with Thorn Necklace and Hummingbird**
Frida Kahlo, oil on canvas, 1940
25 x 19 inches (61 x 47 cm)

MONKEY

A portrait of Kahlo's favourite spider monkey, Caimito de Guayabal, which was a gift from Rivera. Here he plucks anxiously at the thorns around her neck, both sympathetic and disengaged.

BUTTERFLIES & DRAGONFLIES

Painted with the sparkle of jewellery, they bring a brighter note to a composition overloaded with sadness – a suggestion of redemptive optimism.

BLACK CAT

Painted as though it were stalking the hummingbird around her neck.

NECKLACE OF THORNS

Draped like a rebozo around her neck, the thorns are clearly symbols of what Kahlo sees as her martyrdom. They leave trickles of blood where they have pierced her skin.

HUMMINGBIRD

Hanging from the thorns, wings outstretched and apparently dead, the hummingbird is a magic charm for love in Mexican folklore. But it is also the symbol for *Huitzilopochtli*, the Aztec god of war, suggesting that Kahlo has recently fought her own battle.

WHITE SHIRT

Uncharacteristically plain, the unornamented white shirt represents a martyr's robe.

WHAT SHE LEFT BEHIND: 10 EXHIBITIONS OF KAHLO'S WORK

Although she contributed to a number of group exhibitions during her life, Kahlo held only three solo shows: one in New York City, one in Paris and the last in Mexico City, shortly before she died.

However, more than six decades after her death, Kahlo's star has never been higher, and since 2012 there have been a large number of high profile exhibitions (some pairing her work with Rivera's).

NEW YORK CITY 1938
Kahlo's first exhibition. Held at the Julien Levy Gallery.

PARIS 1939
Kahlo's second exhibition, "Mexique". Held at the Renou & Colle Gallery.

MEXICO CITY 1953
The final exhibition of Kahlo's lifetime was held at the gallery of Lola Alvarez Bravo. Already very ill, Kahlo still attended the opening, holding court from her bed.

TORONTO 2012
"Frida & Diego: Passion, Politics and Painting", Art Gallery of Ontario.

PARIS 2013
"Frida Kahlo/Diego Rivera: L'art en Fusion", Musée de l'Orangerie.

ROME 2014
"Frida Kahlo", Scuderie del Quirinale.

DETROIT 2015
"Diego Rivera and Frida Kahlo in Detroit", Detroit Institute of Arts.

NEW YORK 2015
"Frida Kahlo: Art, Garden, Life", New York Botanical Garden.

SEOUL 2015
"Frida Kahlo from the Gelman Collection", Seoul Olympic Museum of Art. Kahlo's work is shown for the first time in South Korea.

ST. PETERSBURG 2016
"Frida Kahlo Retrospective", Fabergé Museum. Kahlo's work is shown for the first time in Russia.

FRIDA
KAHLO

04
LEGACY

"NEVER BEFORE HAD A WOMAN PUT SUCH AGONIZING POETRY ON CANVAS AS FRIDA DID."

—Diego Rivera

FINDING FRIDA

**Madison
Museum of
Contemporary
Art, Madison**

1 painting:
Pitahayas

**Albright-Knox
Art Gallery,
Buffalo**

1 painting:
*Self-Portrait
with Monkey*

**MoMA,
New York City**

3 paintings:
*My Grandparents, My Parents,
and I • Fulang-Chang and I •
Self-Portrait with Cropped Hair*

**SF MoMA,
San Francisco**

1 painting:
*Frieda and
Diego Rivera*

**Hoover Gallery,
San Francisco**

1 painting:
*My Dress
Hangs There*

**National Museum
of Women in
the Arts,
Washington D.C.**

1 painting:
*Self-Portrait
Dedicated to
Leon Trotsky*

**Museo Frida Kahlo
(formerly La Casa
Azul), Mexico City**

10 paintings, including:
*Viva la Vida • Portrait
of My Father • Portrait
of Frida's Family •
Self-Portrait with
Stalin*

**Museo de Arte
Moderno,
Mexico City**

3 paintings:
*The Two Fridas •
Coconuts •
Still Life with
Watermelons*

**Phoenix Art Museum,
Phoenix**

1 painting:
The Suicide of Dorothy Hale

How many works Kahlo painted is moot, as accurate records were not kept during her lifetime. Her work did not attract international attention until some time after her death, and much of it is in private collections. Since her star rose so spectacularly in the 1990s, the picture has also been muddied by the appearance of many forgeries. It is now widely believed that the total number of genuine Frida Kahlo paintings is somewhere in the region of 150–200.

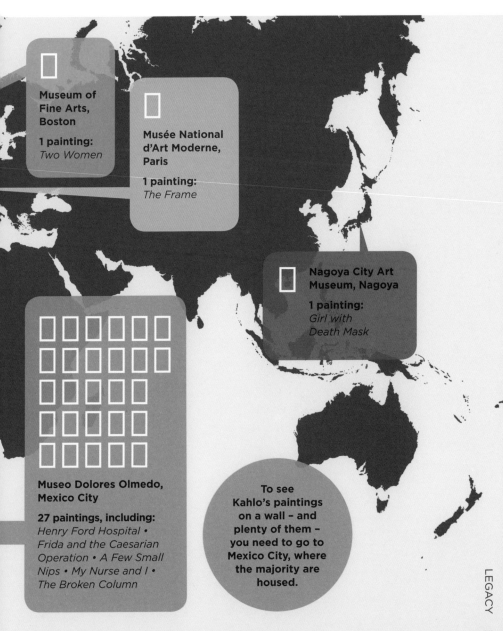

Museum of Fine Arts, Boston

1 painting:
Two Women

Musée National d'Art Moderne, Paris

1 painting:
The Frame

Nagoya City Art Museum, Nagoya

1 painting:
Girl with Death Mask

Museo Dolores Olmedo, Mexico City

27 paintings, including:
Henry Ford Hospital • Frida and the Caesarian Operation • A Few Small Nips • My Nurse and I • The Broken Column

To see Kahlo's paintings on a wall – and plenty of them – you need to go to Mexico City, where the majority are housed.

8 SURPRISING PLACES TO FIND FRIDA

From the time of her first appearances in public, long before her art was widely recognized, Frida Kahlo was gaining recognition for her striking personal style. As in her life, today she is sometimes seen in surprising places, from T-shirts to coffee cups, such is the continuing power of her image.

VOGUE

1939

Kahlo's heavily beringed hand appears on the cover of French *Vogue*, to coincide with her *Mexique* exhibition at Renou & Colle in Paris.

1994

Frida's Fiestas, a memoir of Frida's entertaining at Casa Azul – with recipes – is published. The collaboration is part-written by Rivera's daughter.

2001

Both the US and Mexican post offices issue postage stamps showing Kahlo. However, some Americans still remember her Communist politics and object to the use of her image.

FRIDA KAHLO USA 34
2001

2002

A Spanish paint company puts a range of Frida-inspired colours into production.

2010

Kahlo appears for the first time on the back of Mexico's 500 peso bill (Rivera is shown on the front).

Banco de México

500

Quinientos Pesos

500 Pesos

2010

On the 103rd anniversary of her birth, Kahlo's image ornaments the Google logo.

Kahlo

2012

A Kahlo paper doll book is published, offering 30 different outfits to dress her in (Rivera also features, with two outfits of his own).

2016

Broken Wings, a ballet about Kahlo's life, arranged by the Columbian-Belgian choreographer Annabelle Lopez Ochoa, is performed for the first time in London, England.

FINDS OR FAKES?

In 2009, the book, *Finding Frida Kahlo*, was published. It told how a huge trove of paintings, notebooks, sketches and ephemera, believed to be by Kahlo, had been discovered in a storage room behind an antiques gallery in the little town of San Miguel de Allende about 150 km (90 miles) north-west of Mexico City.

The collection is currently owned by art dealer Carlos Noyola, who bought the assortment from an unnamed lawyer in 2004, who in turn had bought it from Abraham Jiménez López, who carved Kahlo's frames. López claimed Kahlo had given him the collection.

Experts gathered to decry the collection as fake; the owners retorted that they were happy to submit all the pieces for tests. In 2011, a court found that the experts had failed to support their claim that the paintings and other objects were forgeries.

THE CASE AGAINST

- **The signature on all the letters – Frida K. – is rarely found in any of her authenticated letters.**

- **Kahlo's friend, Lola Alvarez Bravo, made a photographic archive of her work, and none of the pieces feature in it.**

- **Kahlo habitually dated her work, but none of the pieces is dated.**

CONTENTS OF THE COLLECTION

16 oil paintings

23 watercolours and pastels

59 notebook pages

73 anatomical studies

128 pencil and crayon drawings

129 prose poems

230 letters to Carlos Pellicer, the modernist poet and Kahlo's close friend

TYPOGRAPHIC KAHLO

tradition

Watermelon

Frida y Diego Rivera

Masonite

anatomy revolution

rebozo

surrealism

tehuana

inspiration

foetus

Pre-Columbian

Viva la Vida

prickly pear

Detroit

colour self-portrait

bonito New York City hummingbird spirit

33 operations
amputation
Communist
tequila
Fridamania
Leon Trotsky
Georgia O'Keeffe
calavera
Casa Azul
ribbon around a bomb
Stalinism
legacy
polio
San Francisco
Fulang-Chang
monkey
accident
fiesta
feminist
lover
Itzcuintli dog
retablo
huipil
wounded
Palacio de Bellas Artes
journal
Mexico

KAHLO AT AUCTION

In April 1977, Kahlo's 1946 self-portrait, *Tree of Hope, Remain Strong*, became the first of her works to be sold at auction, achieving $19,000 at Sotheby's in New York City. By 1990, Kahlo's star was rising, and *Diego and I* realized $1.4 million at auction, making Kahlo the first Latin-American artist to command more than $1 million for a single work.

Kahlo's paintings appear very rarely at auction and the Mexican government no longer allows the export of any of her paintings currently located in Mexico. This perhaps explains, in part, why the prices a Kahlo painting can command may seem to have increased impressively over the last 70 years.

$19,000	**$44,000**	**$198,000**	**$1,430,000**	**$1,650,000**
1977	**1979**	**1988**	**1990**	**1991**
Tree of Hope, Remain Strong (1946)	*Self Portrait with Monkey* (1940)	*Portrait of Cristina, My Sister* (1928)	*Diego and I* (1949)	*Self-Portrait with Loose Hair* (1947)

$8,000,000
$7,000,000
$6,000,000
$5,000,000
$4,000,000
$3,000,000
$2,000,000
$1,000,000

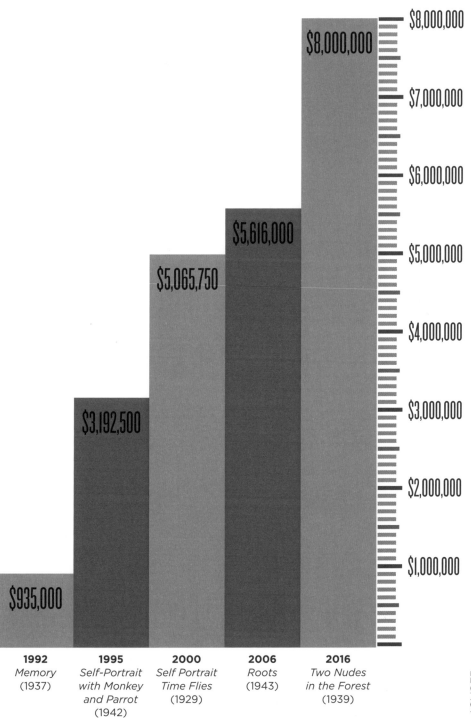

$8,000,000

$8,000,000

$7,000,000

$6,000,000

$5,616,000

$5,065,750

$5,000,000

$4,000,000

$3,192,500

$3,000,000

$2,000,000

$1,000,000

$935,000

1992
Memory
(1937)

1995
*Self-Portrait
with Monkey
and Parrot*
(1942)

2000
*Self Portrait
Time Flies*
(1929)

2006
Roots
(1943)

2016
*Two Nudes
in the Forest*
(1939)

KAHLO'S EPHEMERA

Today, Casa Azul is the Museo Frida Kahlo. One of its many charms is that its displays cover every aspect of Kahlo's life, from her art to the smallest and least significant of her possessions.

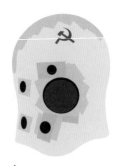

10 **display items to be seen at Casa Azul**

03

Kahlo's plaster corset, painted with a red hammer and sickle design.

02

The artist's prosthetic leg, complete with an elegant red, laced boot ornamented with dragon motifs.

01

Cat's-eye sunglasses with golden frames.

04

Hanging pegs in the kitchen, arranged in patterns of "Frida" and "Diego".



05

Small framed portraits of Mao, Stalin and Lenin.

06

A ceramic clock dated to mark the point Kahlo decided to divorce Rivera ("1939, September, the hours were broken").

07

A ceramic clock marking the day (8 December 1940) when they remarried.

09

A complete set of household accounts, in numerous binders, still on the shelves.

08

Large, traditional papier-mâché "Judas" figures standing guard in the studio.

10

Kahlo's plaster death mask, wrapped around with a rebozo and laid on her bed.

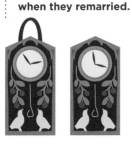

MUSEO
FRIDA KAHLO

BIOGRAPHIES

Lucienne Bloch (1909–99)
Swiss-born American artist who studied at the École des Beaux-Arts in Paris. She worked as an apprentice with Rivera and was a close friend of Kahlo. She took many documentary photographs of both Kahlo and Rivera.

Alejandro Gómez Arias (died 1990)
Kahlo's fellow student at the Preparatoria, and her first serious relationship. They separated in 1928, but remained friends. Gómez Arias went on to become a respected lawyer and political journalist.

Cristina Kahlo (1908–64)
Kahlo's younger sister and frequent companion when Kahlo was at home in Mexico. Although it was probably Cristina's affair with Rivera in 1934 that prompted the couple's divorce, the sisters reconciled and remained close.

Andrés Iduarte (1907–84)
Contemporary of Kahlo's at the Preparatoria. Later a distinguished writer and, in the early 1950s, director of the National Institute of Fine Arts in Mexico City. Iduarte gave the oration at Kahlo's funeral.

Nickolas Muray (1892–1965)
Hungarian-born American artist and photographer, who took many photographs of Kahlo. The couple had a relationship from 1931 that lasted for a decade, and were lifelong friends.

Isamu Noguchi (1904–88)
American modernist artist and sculptor. Noguchi met Kahlo in 1936 while he was in Mexico executing a mural commission in Mexico City. They had a brief relationship and remained friends.

Lola Alvarez Bravo (1903–93)
Mexican photographer and gallerist, known for her photographs of everyday life. Also an accomplished portrait photographer, she took many of the best-known pictures of Kahlo and gave her her first solo exhibition in Mexico.

Dr Leo Eloesser (1881–1976)
American surgeon who lived in San Francisco and who met Kahlo in 1930 during her odyssey in the USA. He became her lifelong confidante, correspondent and health advisor.

Guadalupe (Lupe) Marín (1895–1983)
Novelist, model and Diego Rivera's second wife who was to become a friend of Kahlo, his third. She was a popular artist's model, posing for portraits by Kahlo and photographs by Edward Weston, as well as featuring in murals by Rivera.

Tina Modotti (1896–1942)
Italian-born actor, photographer and model. Born in Italy, but emigrated to America as a teenager. She posed for Rivera's mural, *Creation*, and it is probably through Modotti that Rivera and Kahlo met.

Leon Trotsky (1879–1940)
Russian Marxist revolutionary, writer and member of the first Politburo. Expelled from the Communist Party in 1927 and exiled in Mexico from 1937. For a time, Trotsky lived in Casa Azul at Rivera and Kahlo's invitation.

Diego Rivera (1886–1957)
Mexican artist and one of *los tres grandes* ("the big three") of the Mexican Mural movement (the other two were José Clemente Orozco and David Alfaro Siqueiros). Almost twice Kahlo's age when they married, and she was his third wife.

● family ● lover
● professional ● friend ● spouse

INDEX

FRIDA'S PALETTE